hongdandan

tonight

only

one

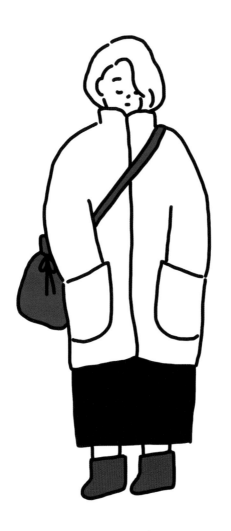

hongdandan

blue day

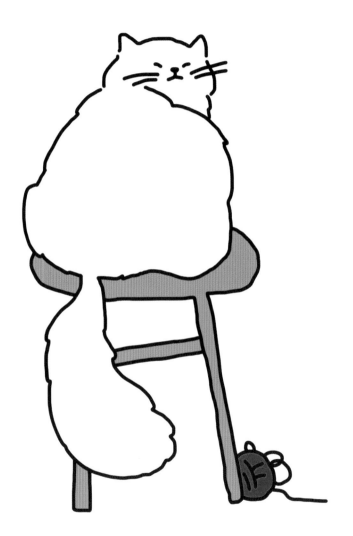

hongdandan

hongdandan

tulip

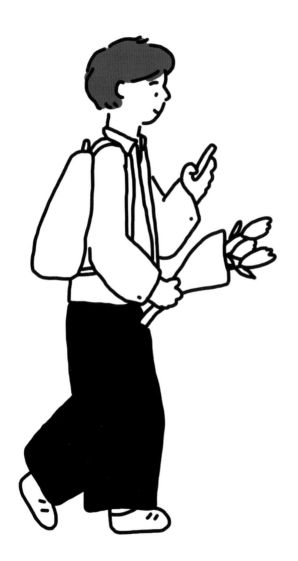

hongdandan

the way to meet 1

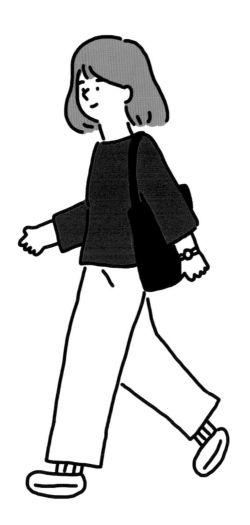

the way to meet 2

hongdandan

pray without ceasing

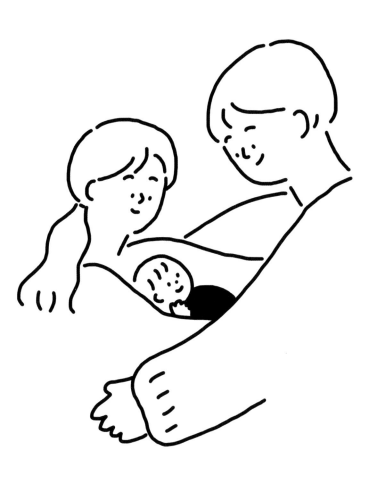

hongdandan

hongdandan

meal

acorn

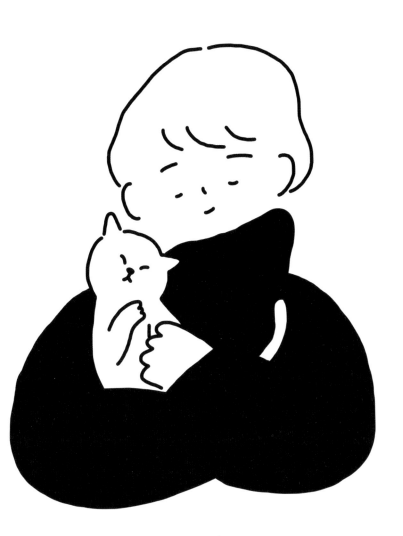

hongdandan

my sweety

hongdandan

flower

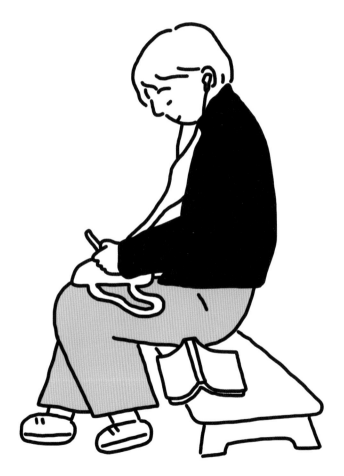

hongdandan

waiting for you

object

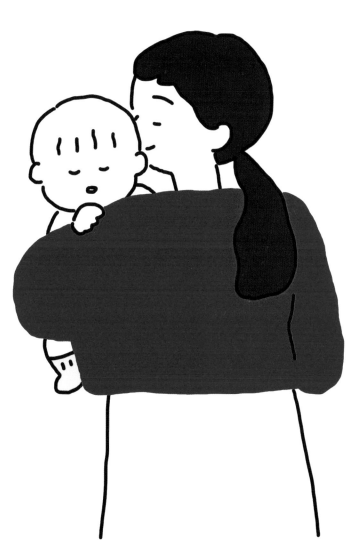

sweet heart

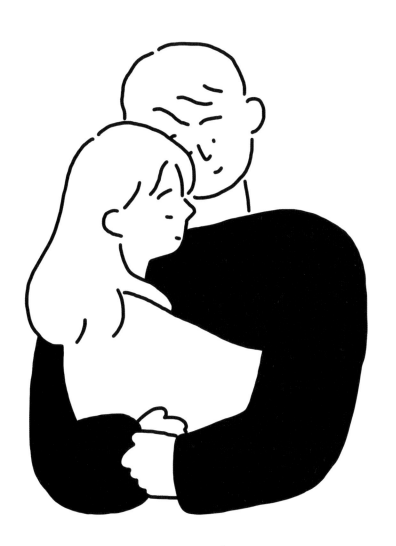

hongdandan

love you

breakfast

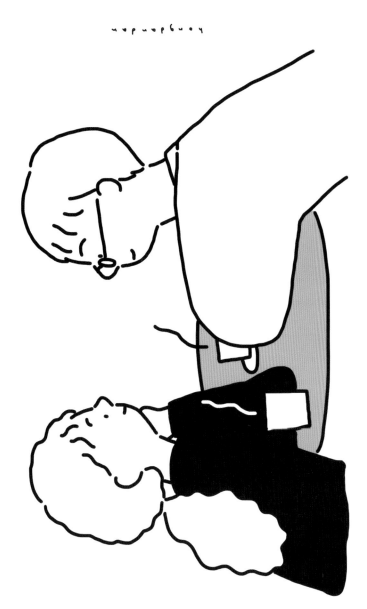

coffee

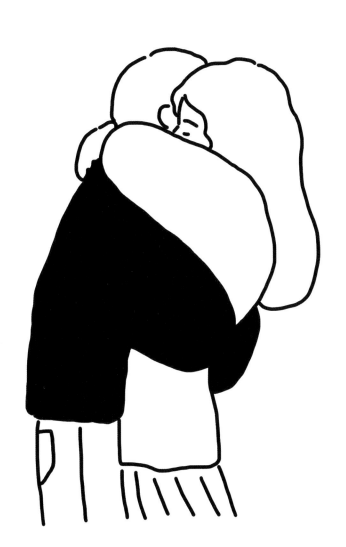

POST

missed you

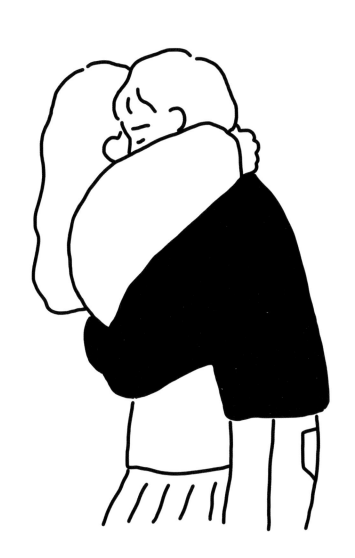

missed you too

BIG LOVE

hongdandan

comfy

flower 2

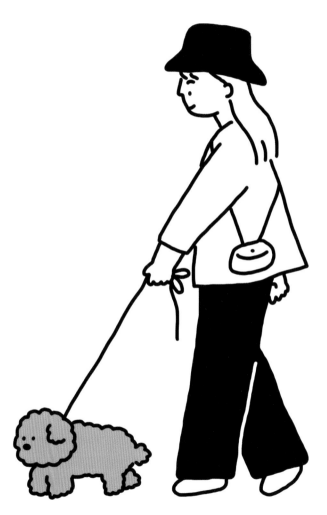

hongdandan

friend

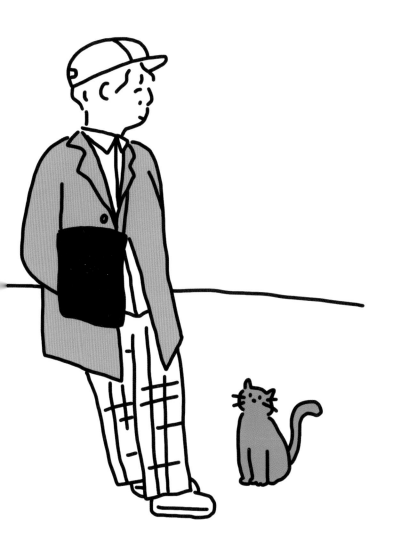

hongdandan

hello

*forest*

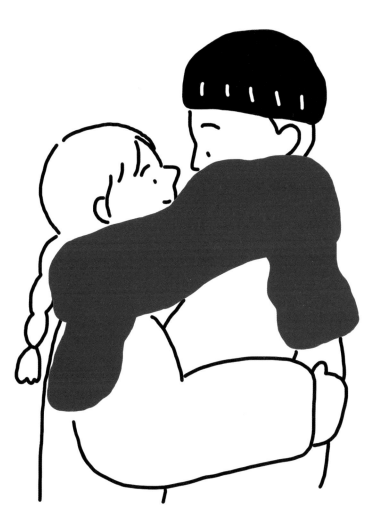

hongdandan

hug

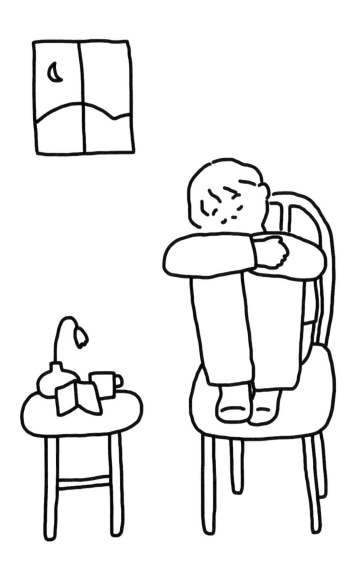

hongdandan

tonight

hongdandan

cat

hongdandan

the way to meet

'

the way to meet 2

hongdandan

acorn

hongdandan

waiting for you

sweet heart

hongdandan

coffee

hongdandan

hug